Animal Gala∖

COLORING BOOK

Mary and Javier Agredo

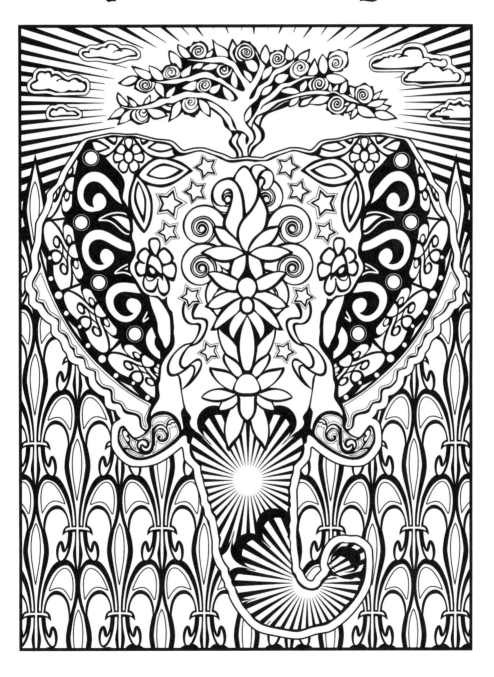

DOVER PUBLICATIONS, INC.
MINEOLA, NEW YORK

This coloring book for the experienced colorist features thirty-one highly stylized images of animal faces, including a fox, a bull, and a tiger. They are done in the tradition of the Day of the Dead and appear on mesmerizing backgrounds. And although *calaveras* means "skulls" in Spanish, these illustrations are not just bare bones! In addition, the pages are perforated and are printed on one side only for easy removal and display.

Bibliographical Note

Animal Calaveras Coloring Book is a new work,
first published by Dover Publications, Inc., in 2016.

International Standard Book Number

ISBN-13: 978-0-486-80571-9
ISBN-10: 0-486-80571-9

Manufactured in the United States by RR Donnelley
80571901 2016
www.doverpublications.com

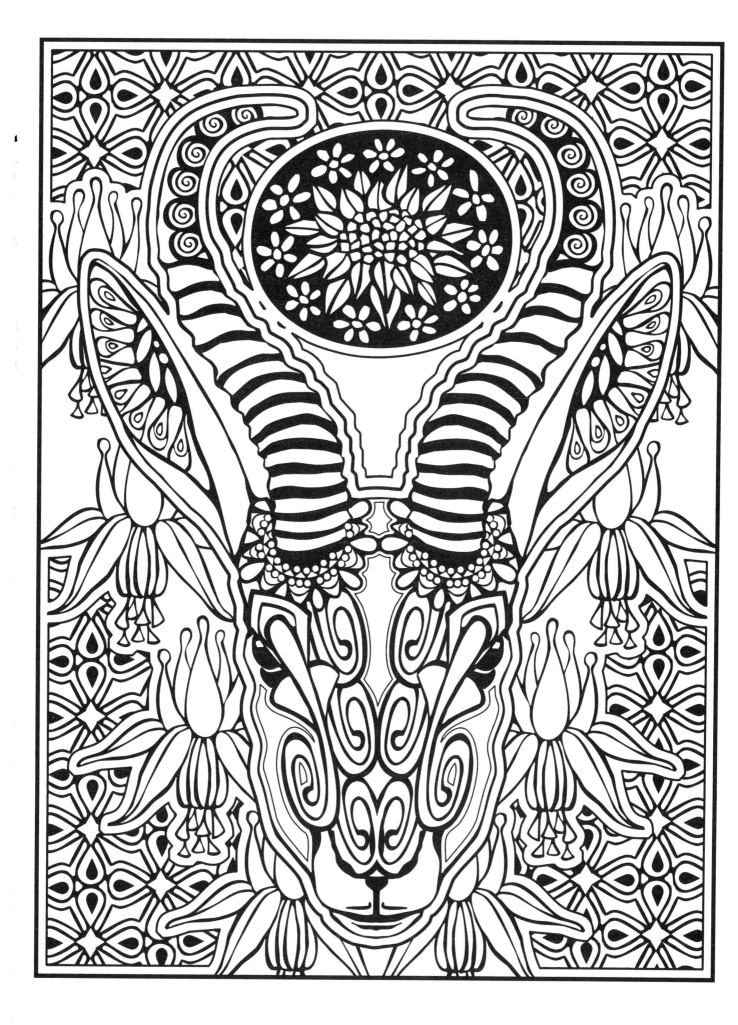

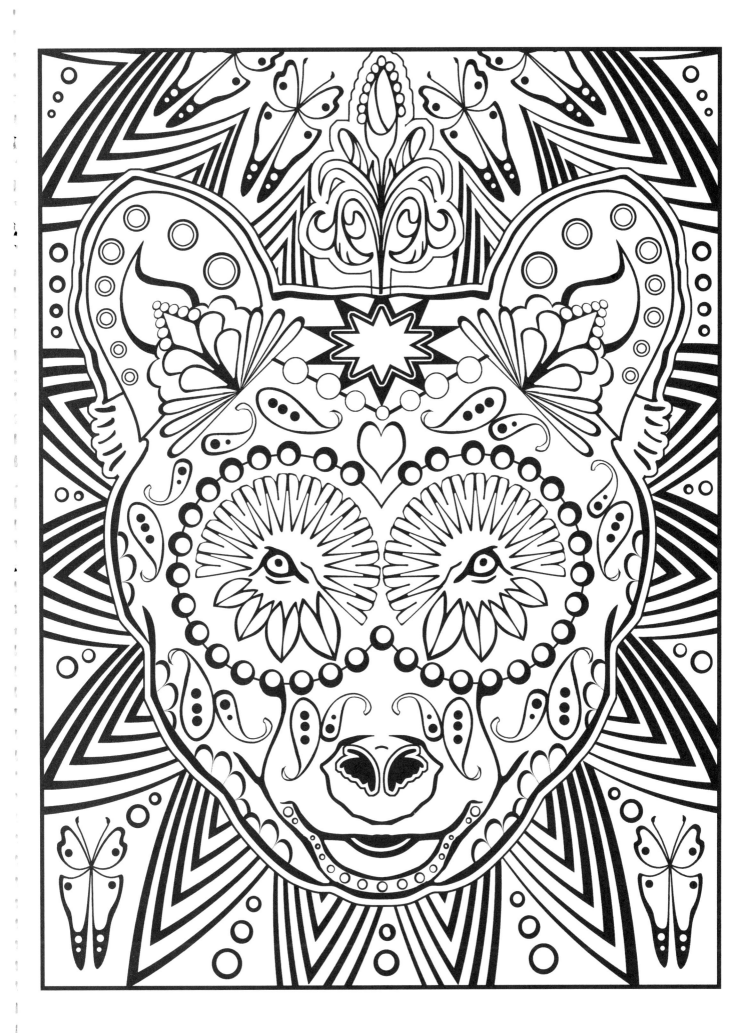

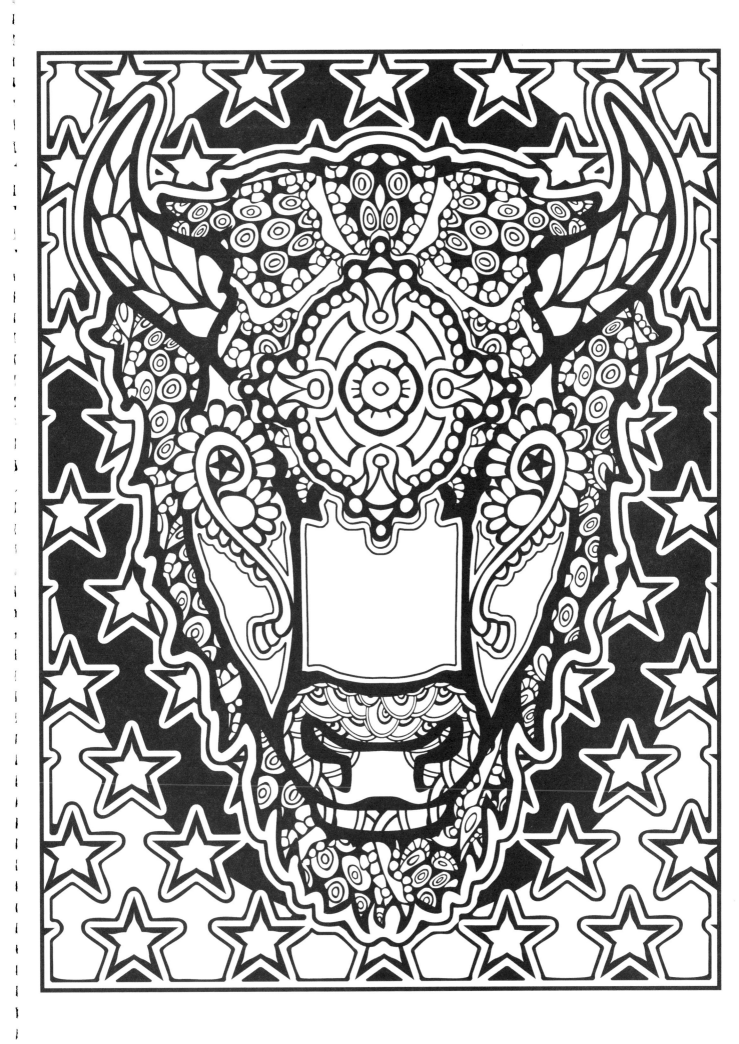

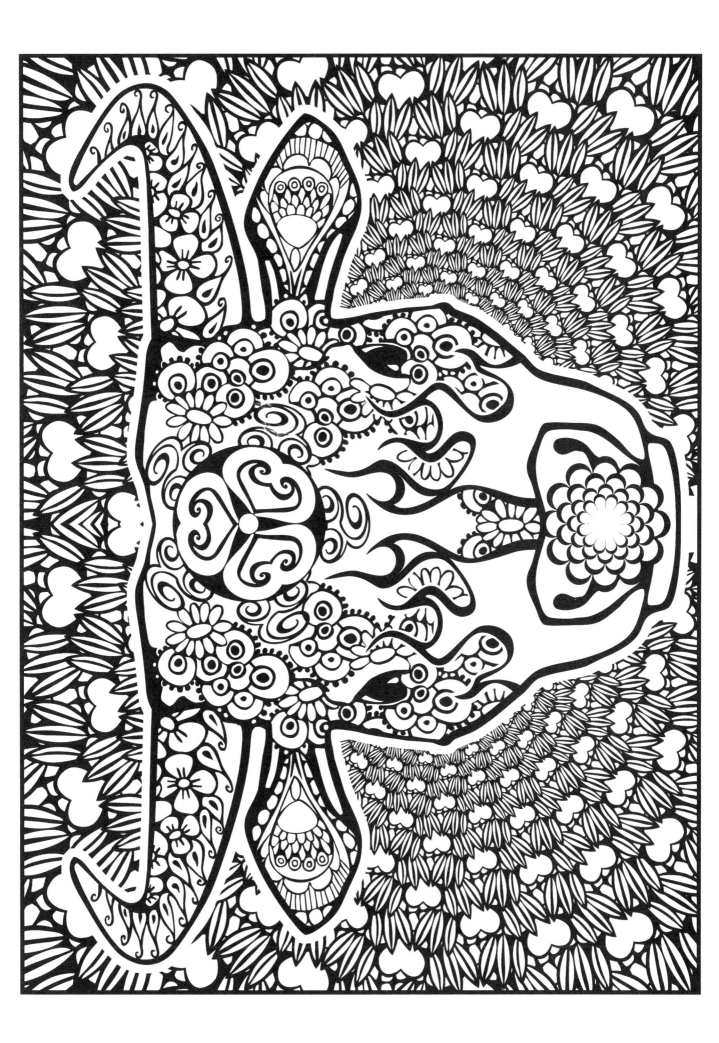

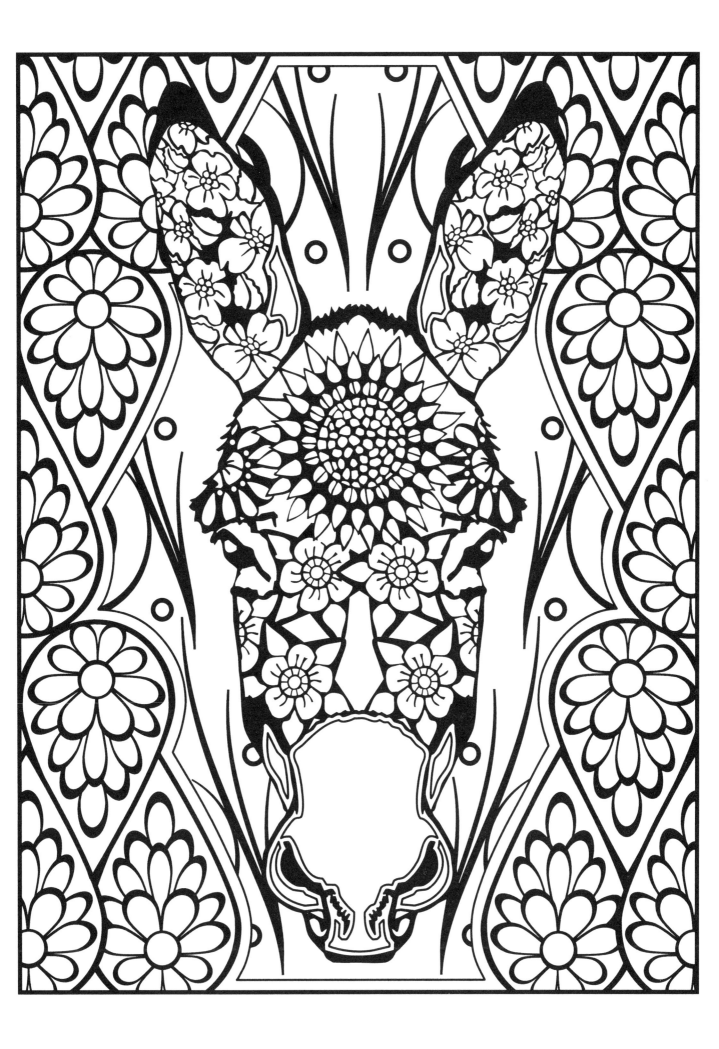

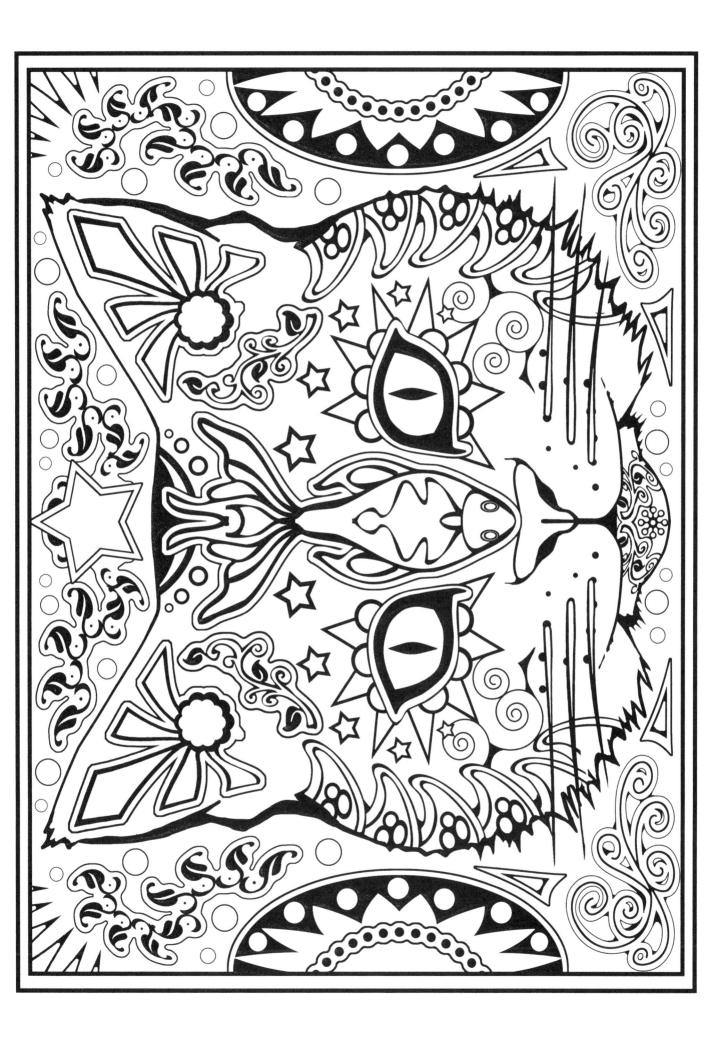

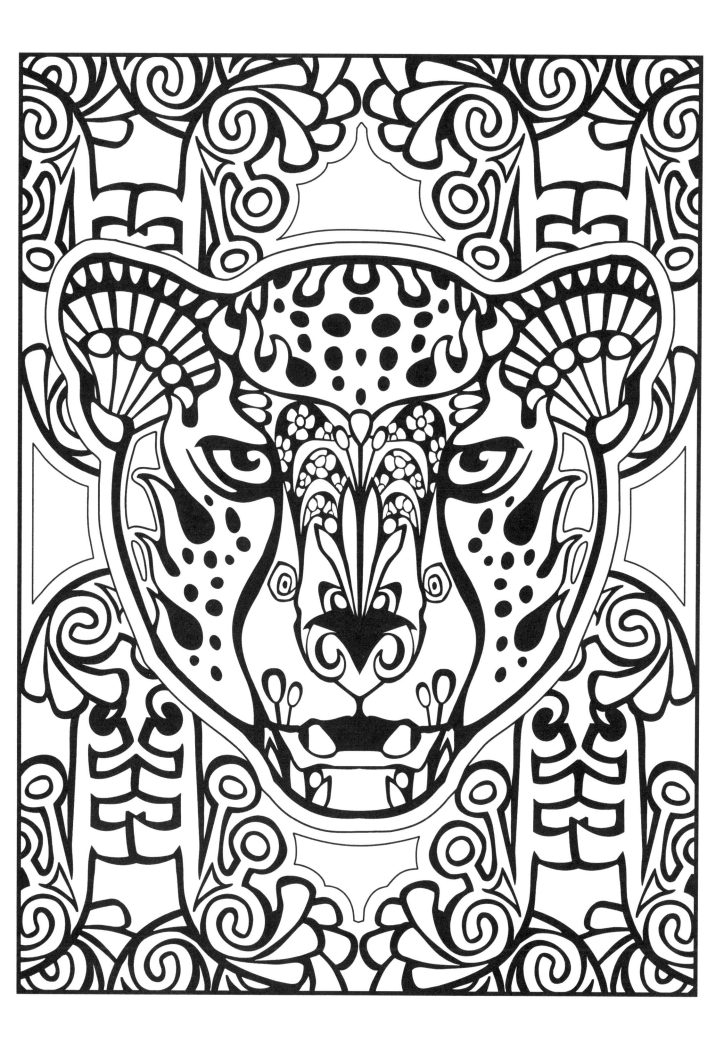

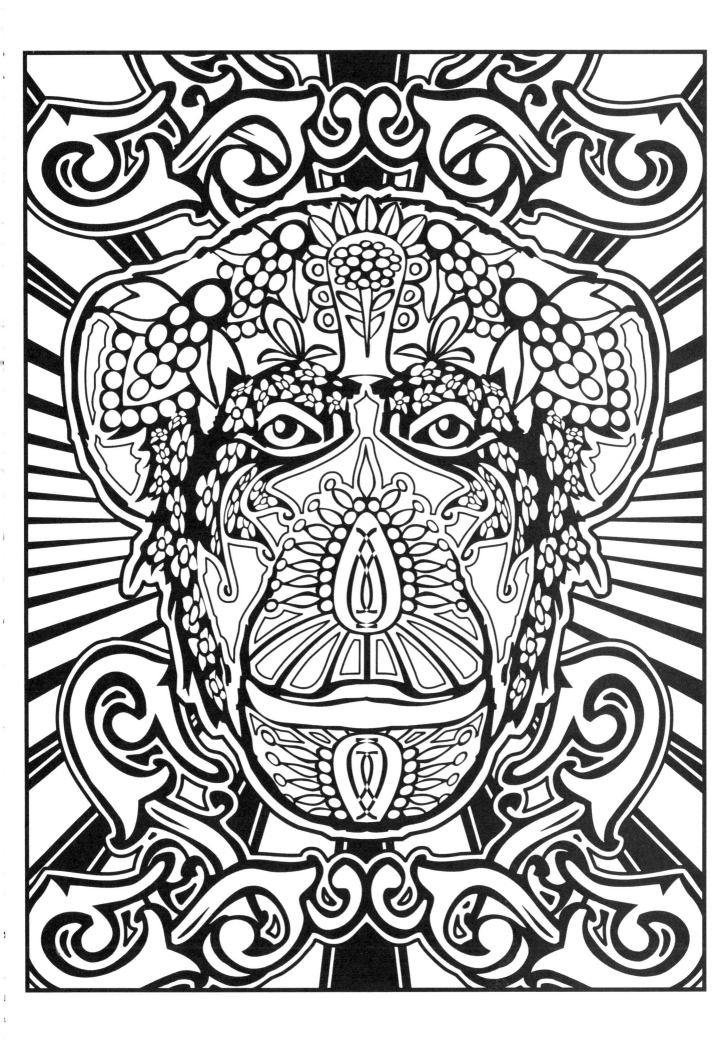

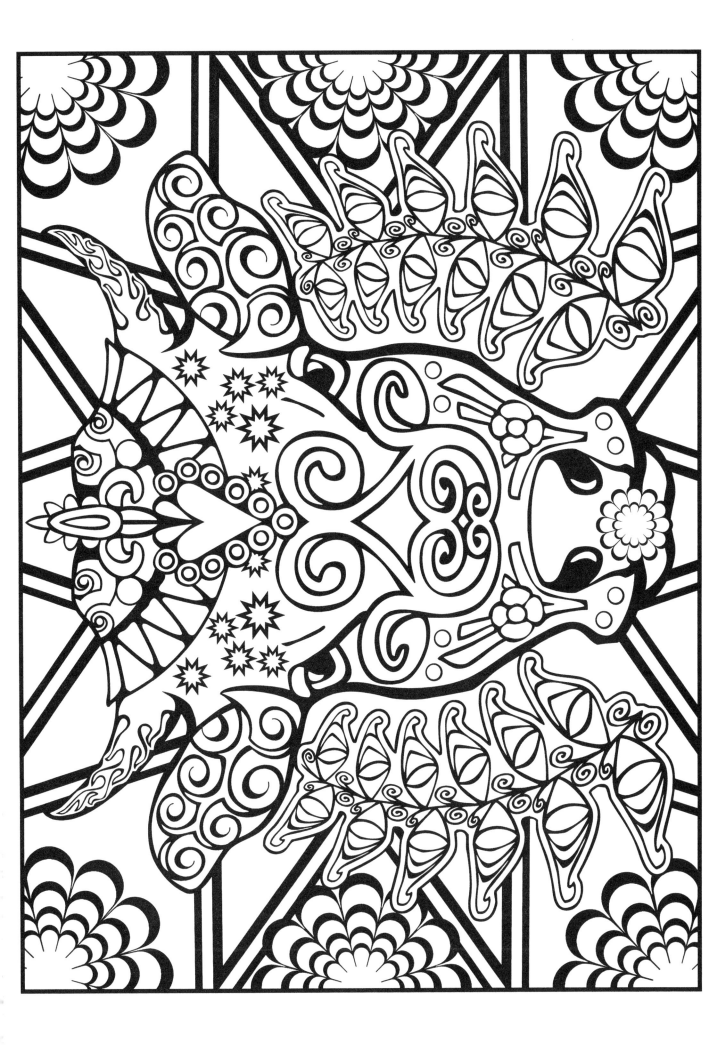

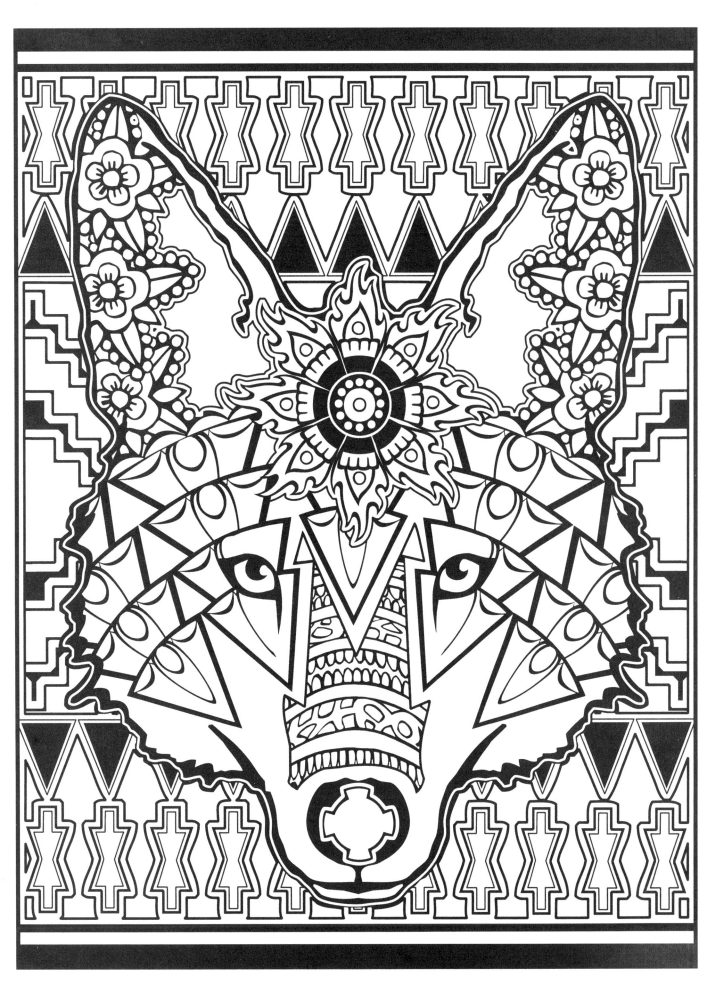

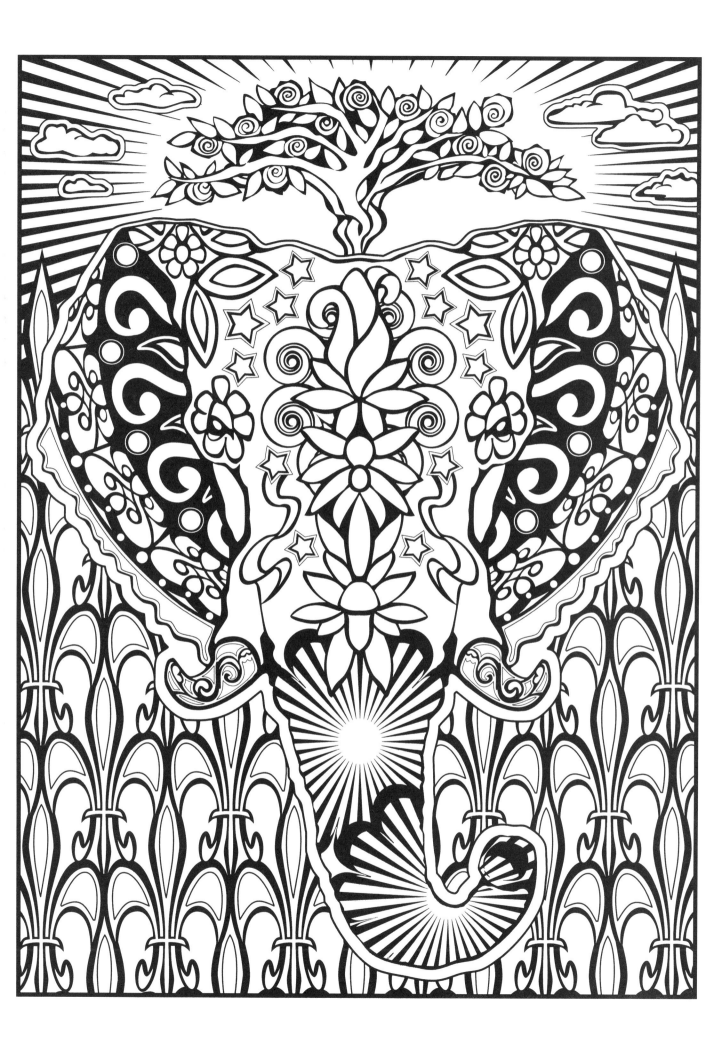

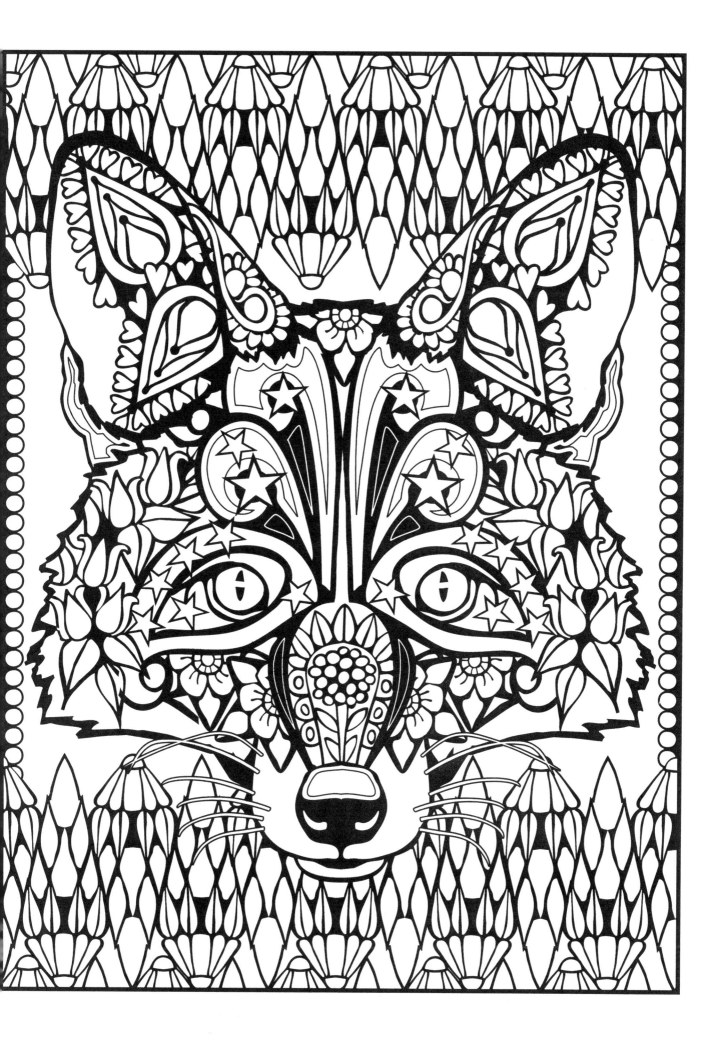

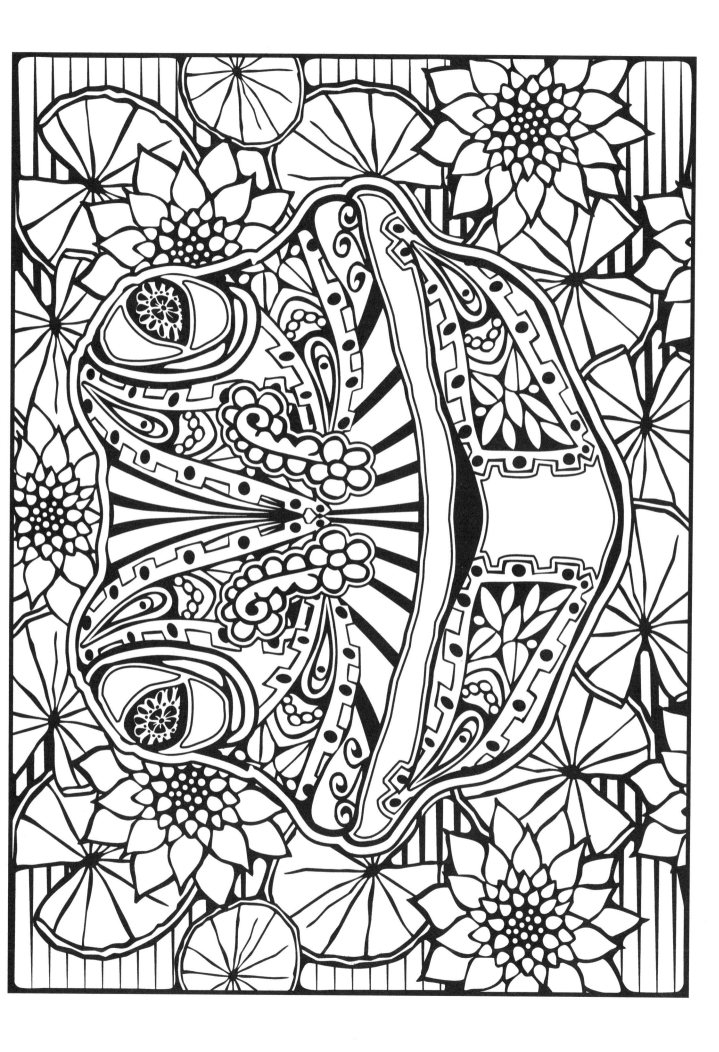

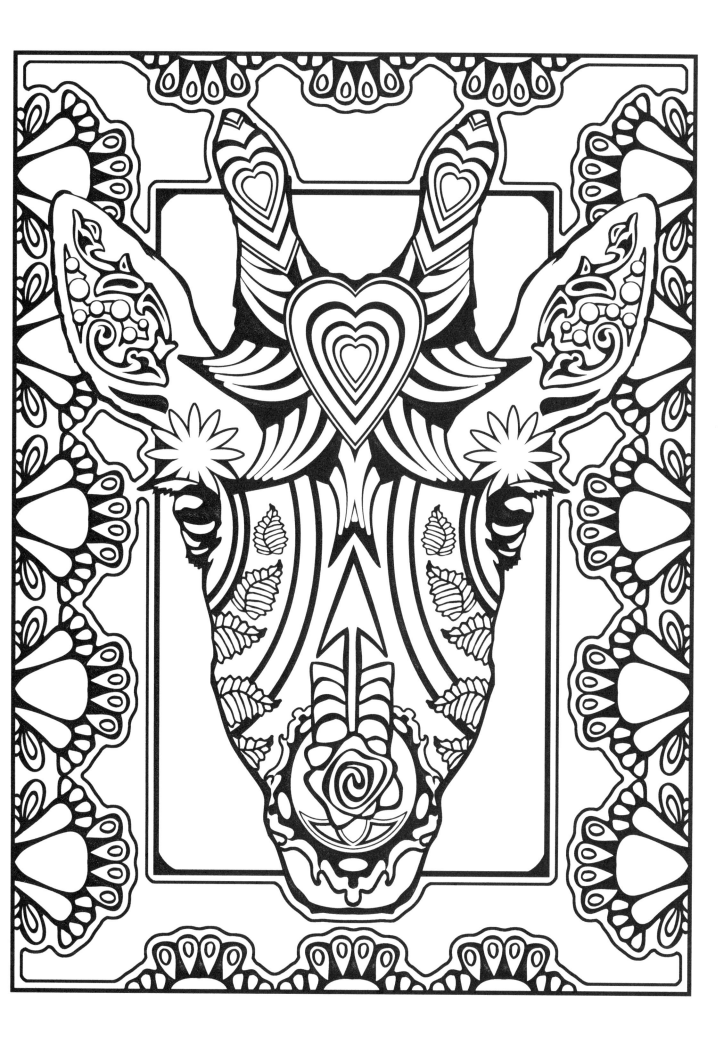

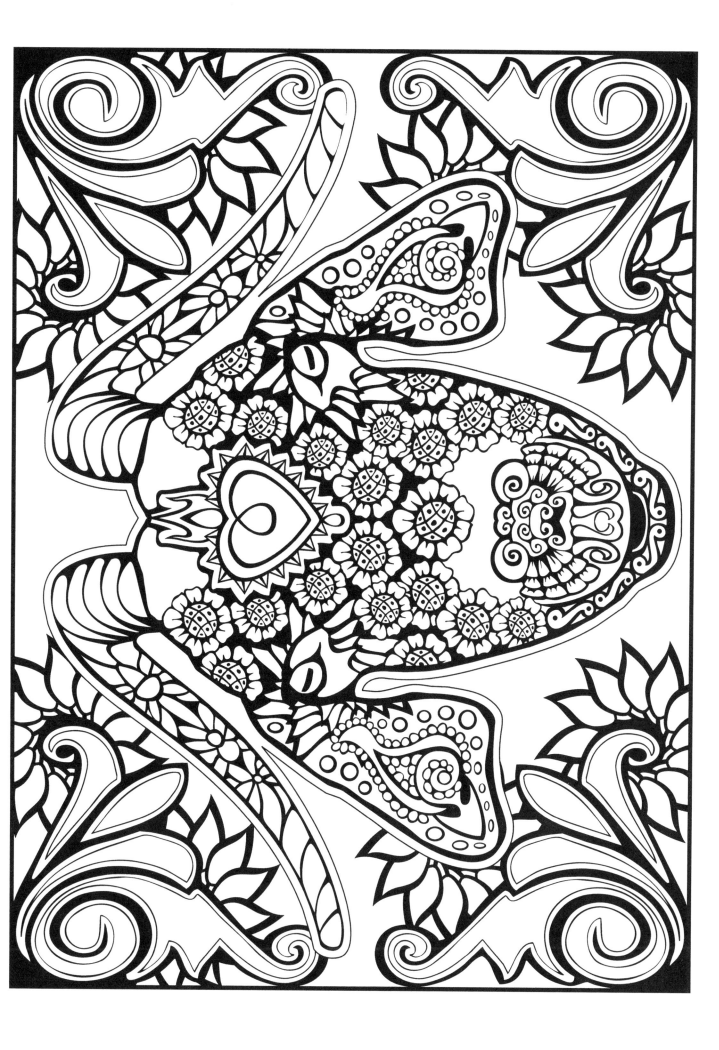

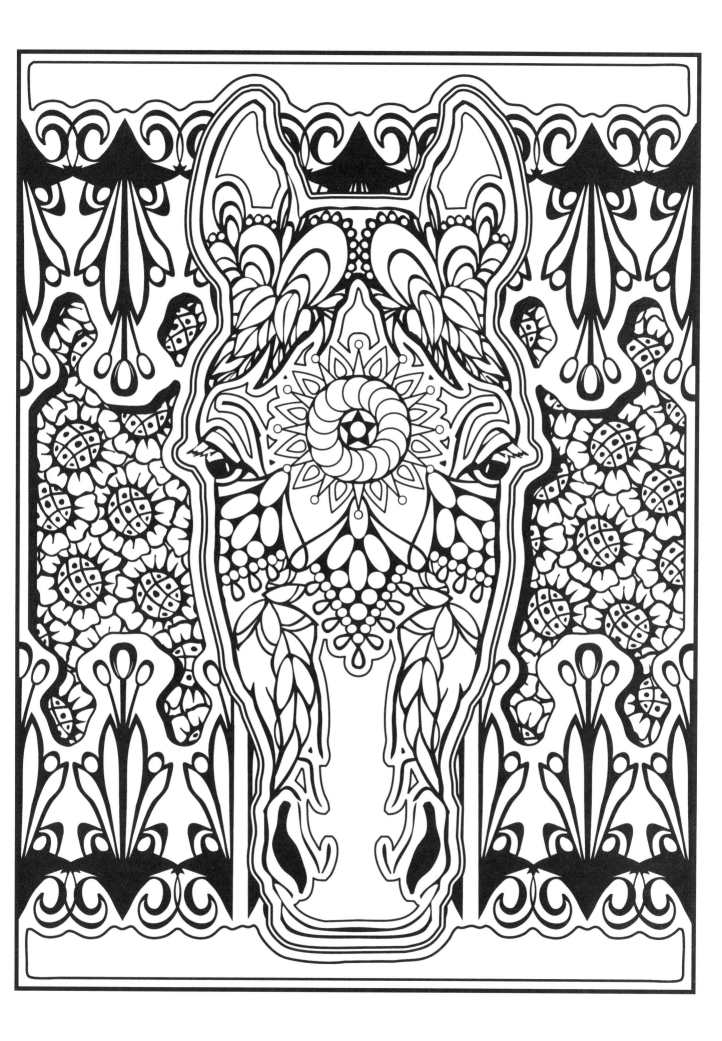

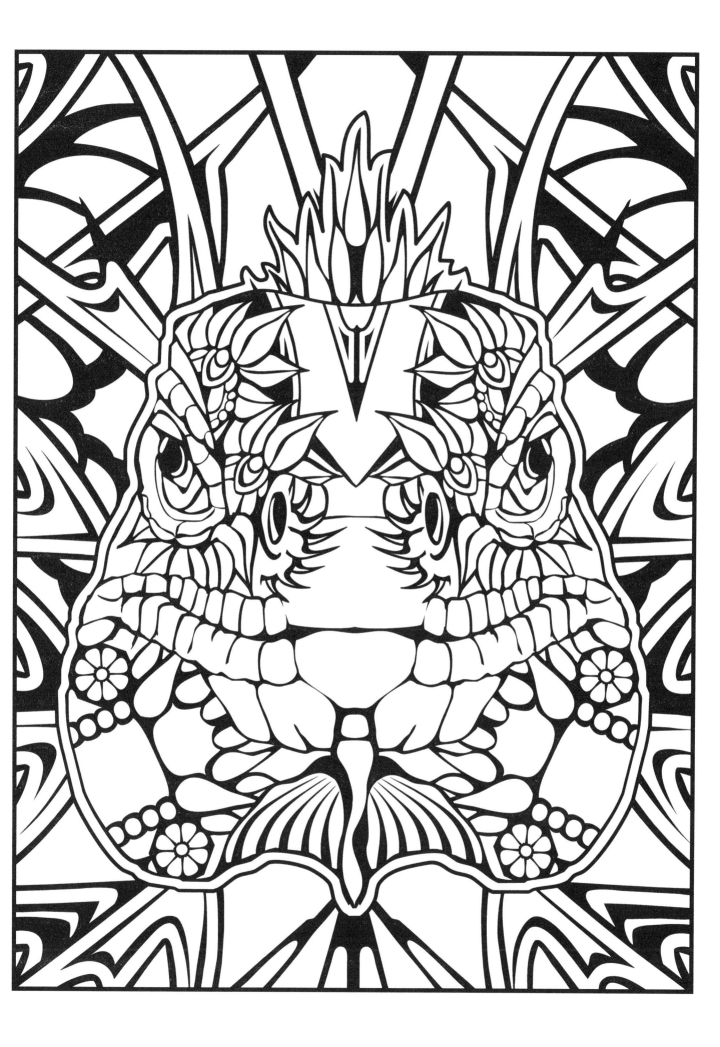

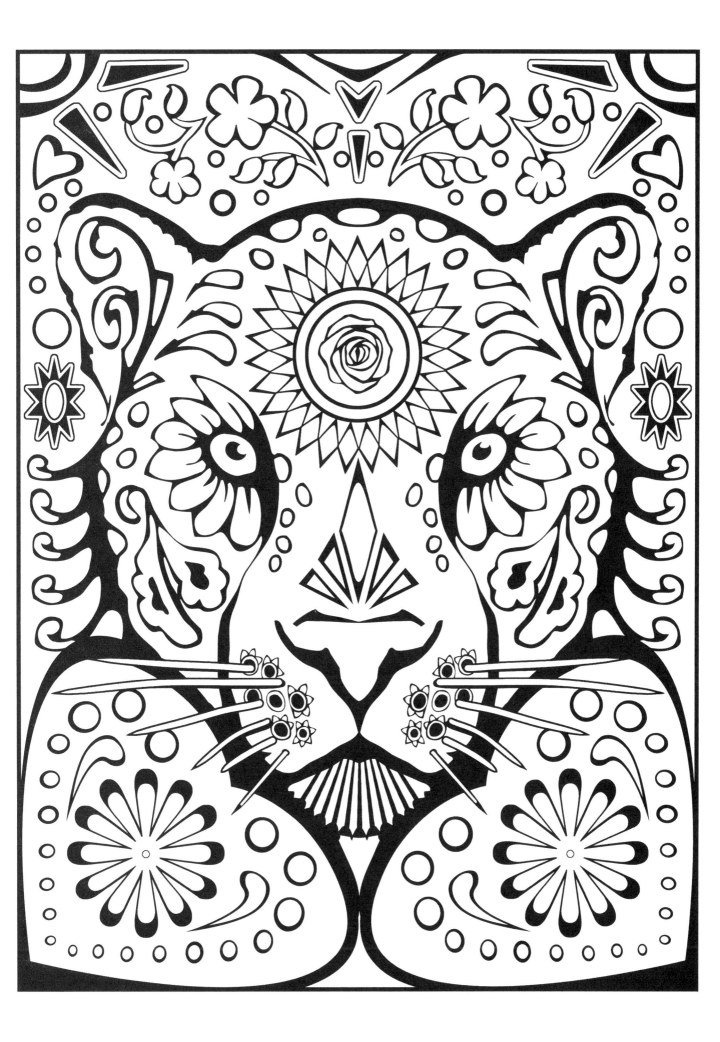

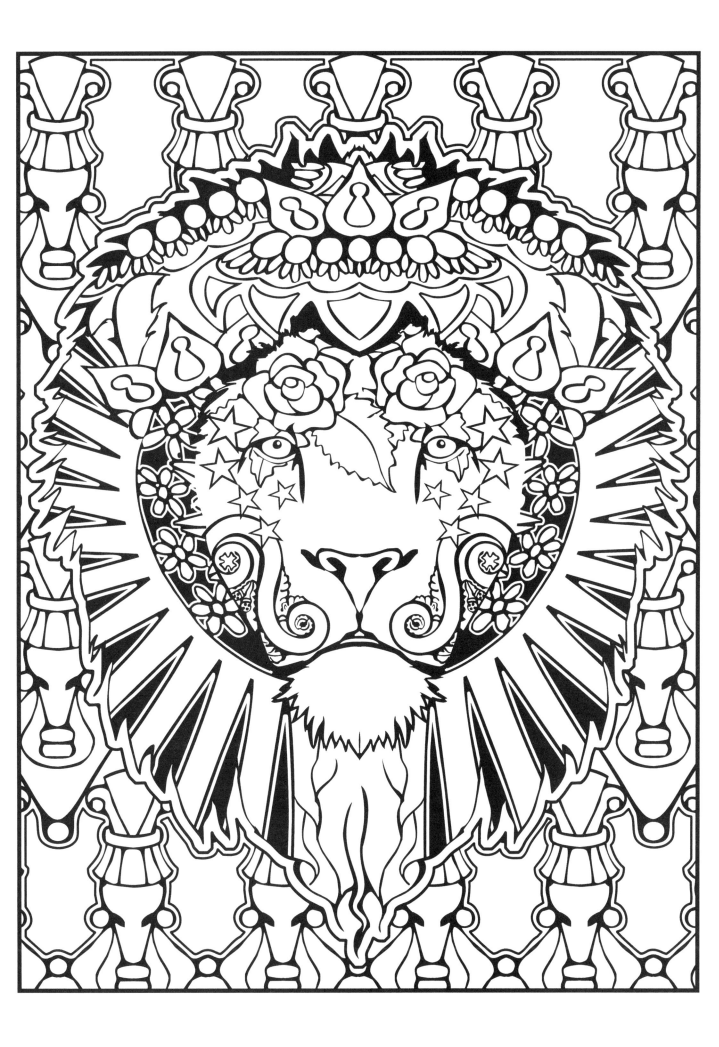

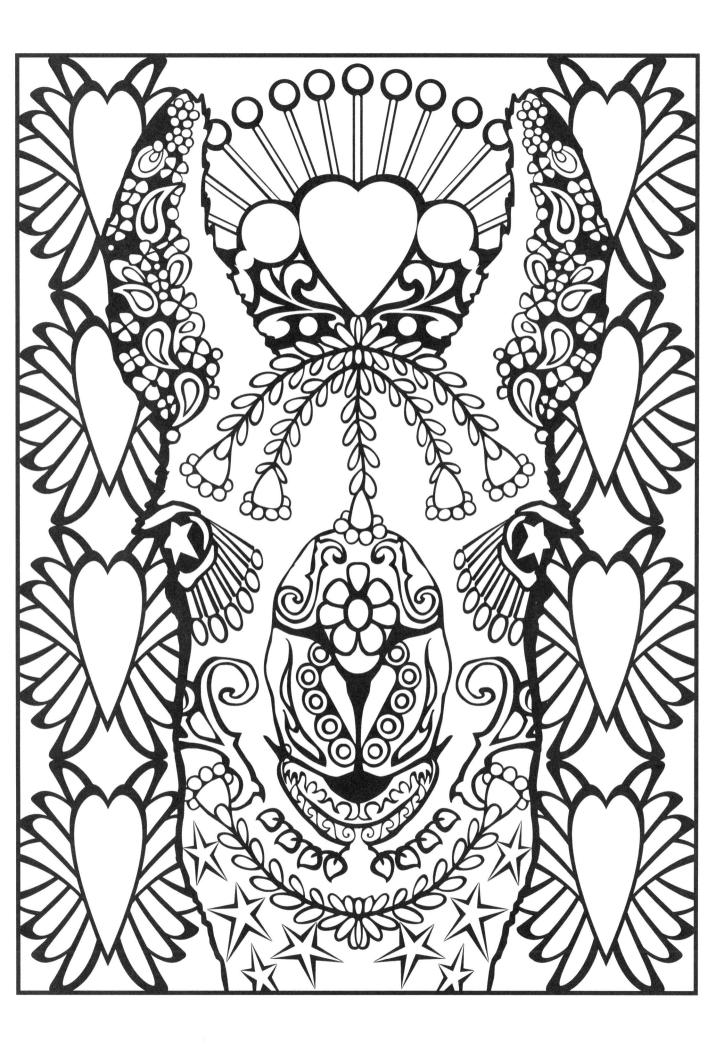

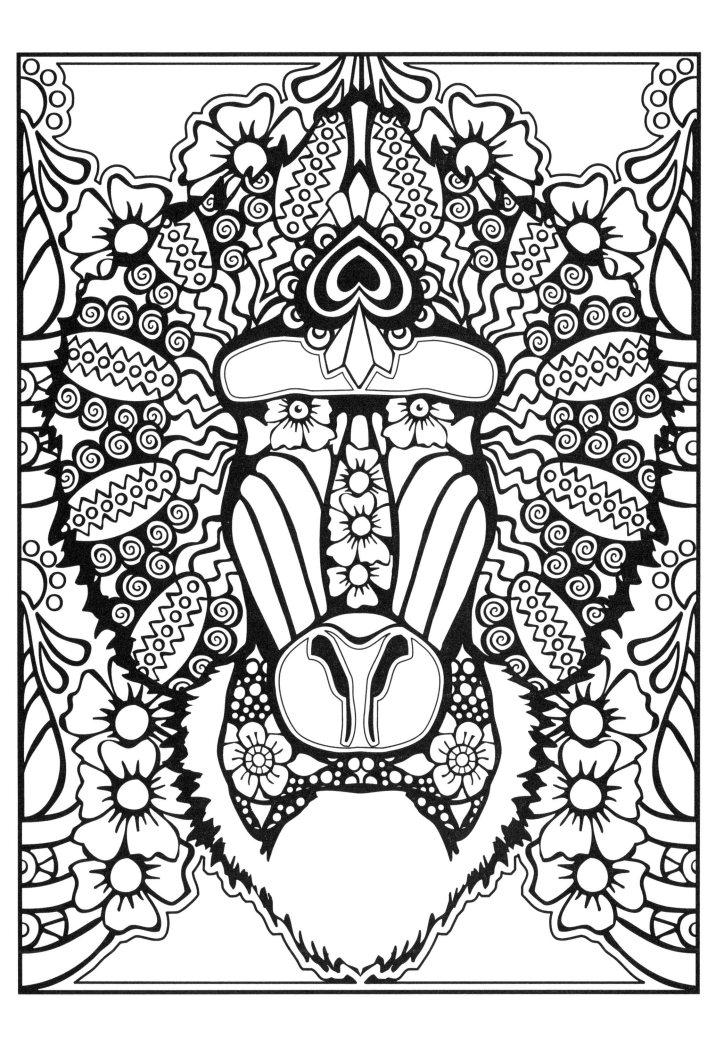

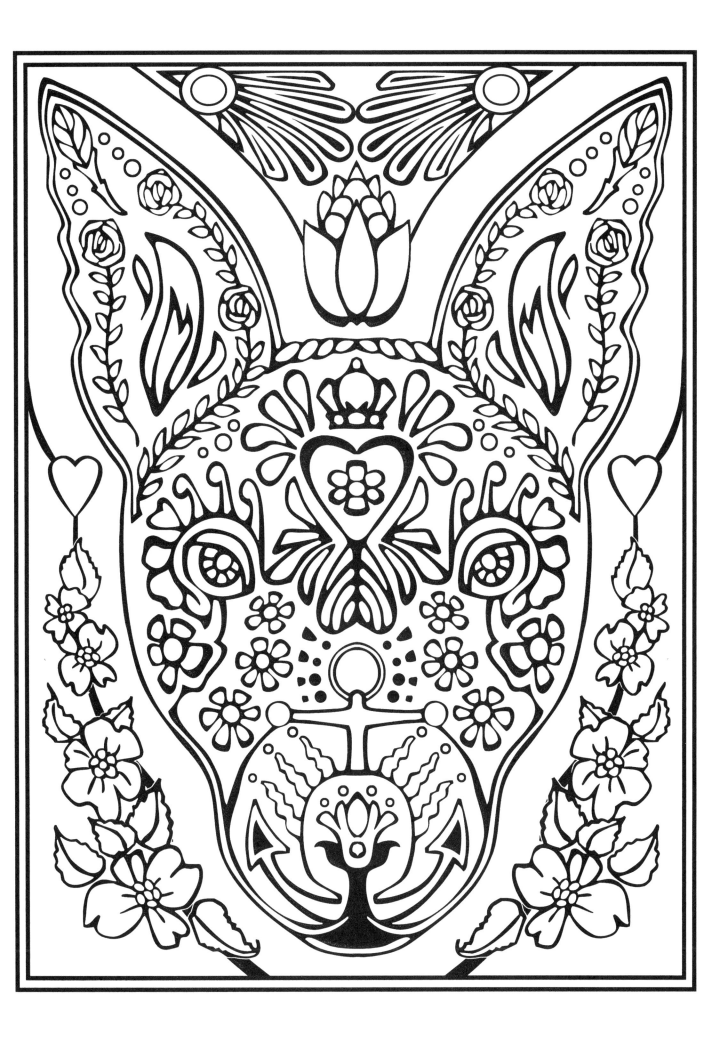

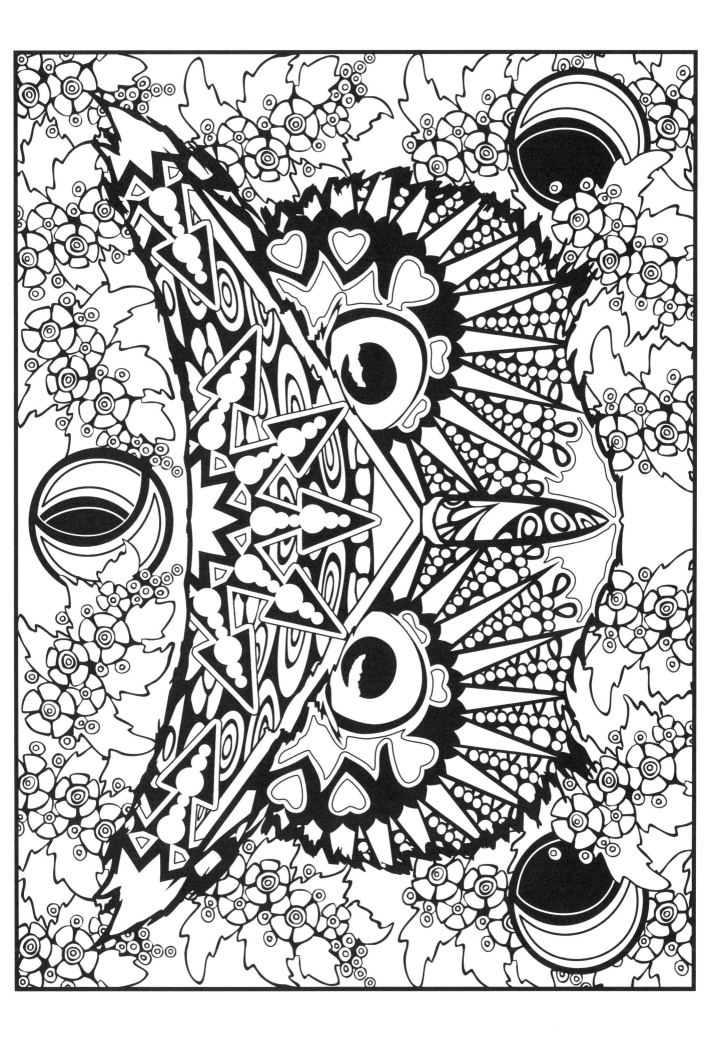

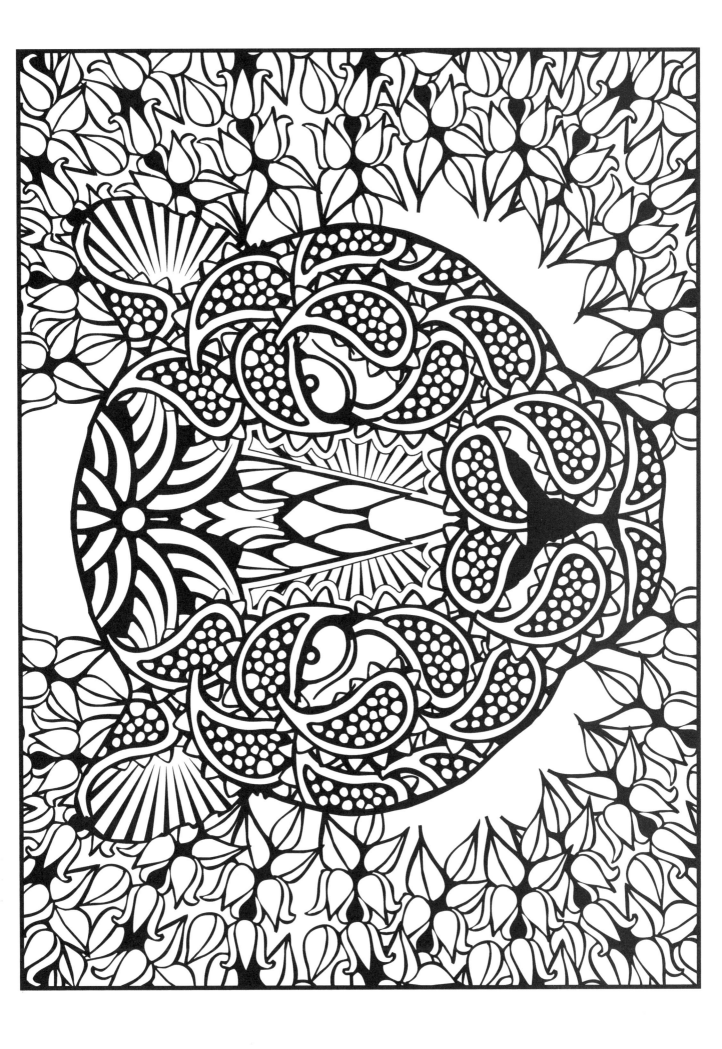

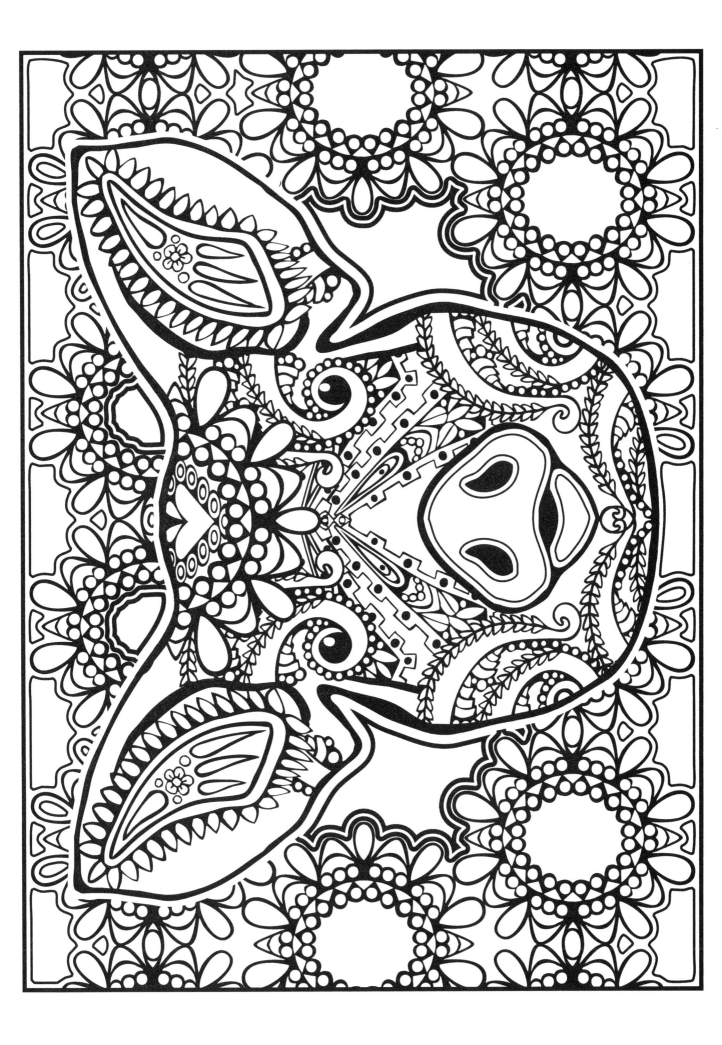

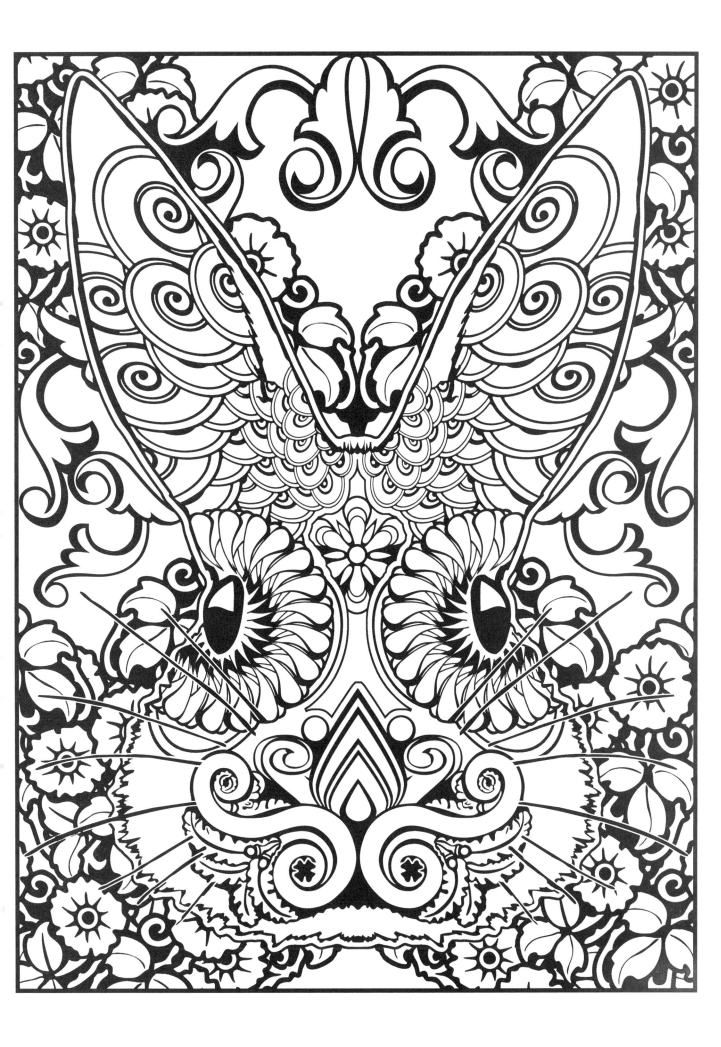

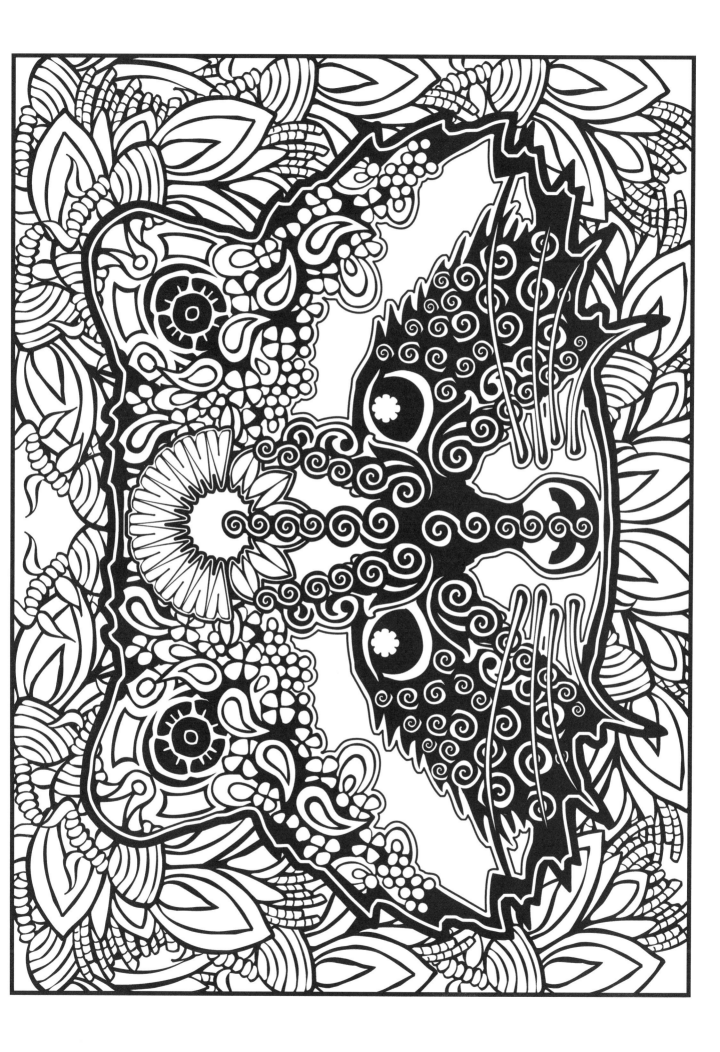

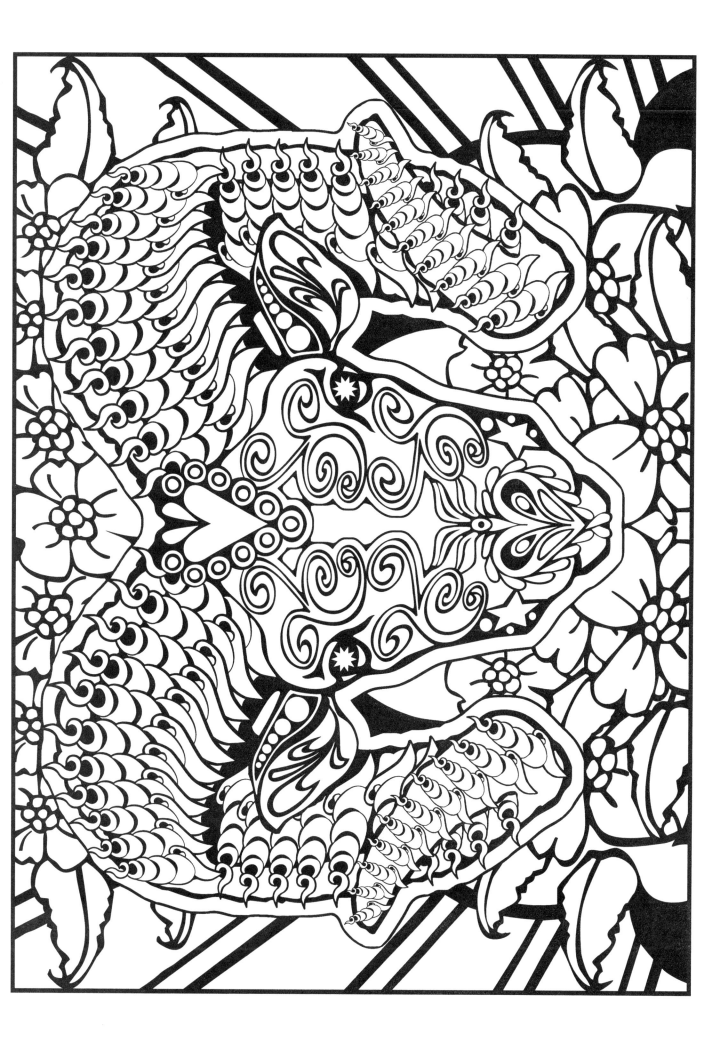

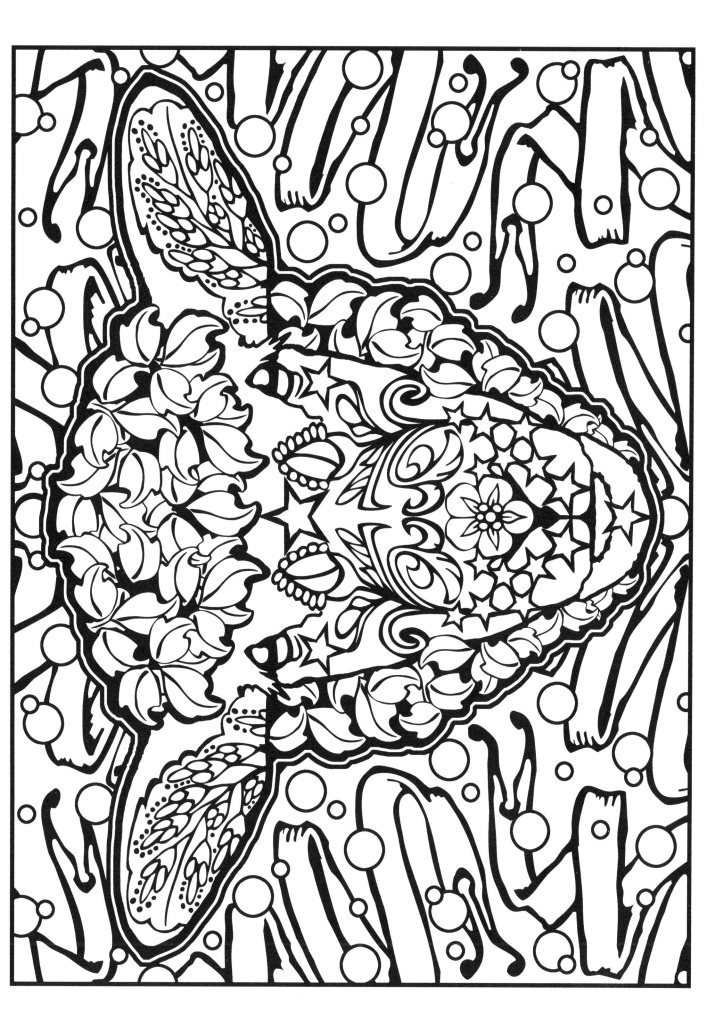

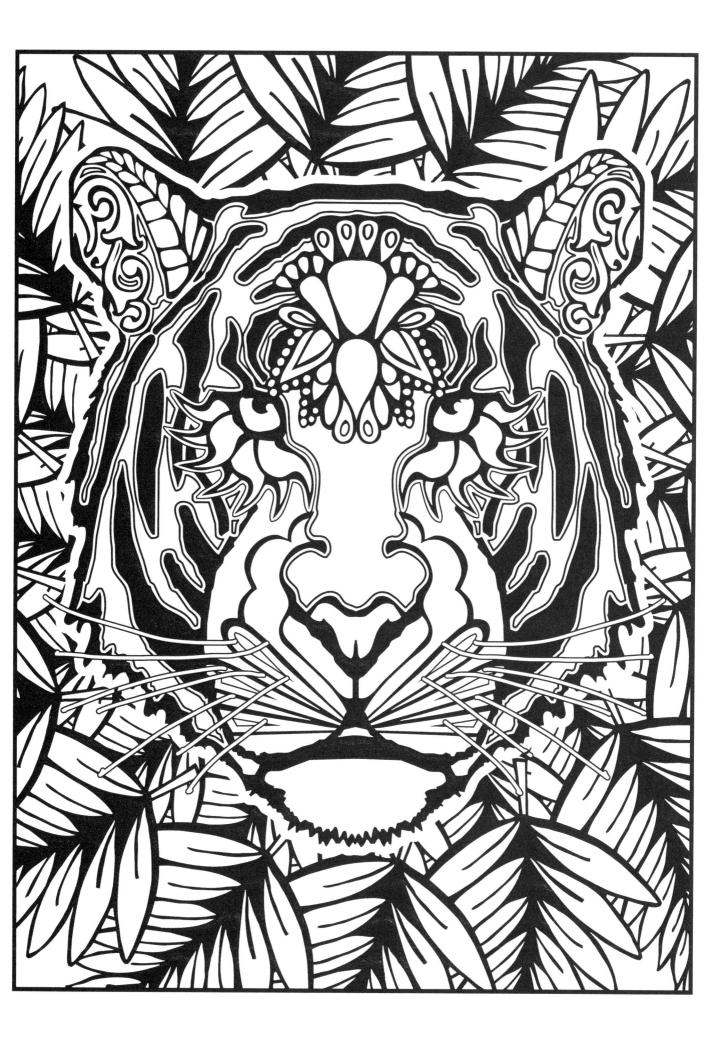